AD LUMEN PRESS

American River College

EROS
ZERO
DANIEL
ROUNDS

Darrel Rounds

PHOTOGRAPHY BY
JESSE VASQUEZ

 Ad Lumen Press | Sacramento | 2017

Ad Lumen Press | American River College
4700 College Oak Drive, Sacramento, CA 95841

Part of the Los Rios Community College District

First Printing

TABLE OF CONTENTS

PHOTOGRAPHS

EROS ZERO

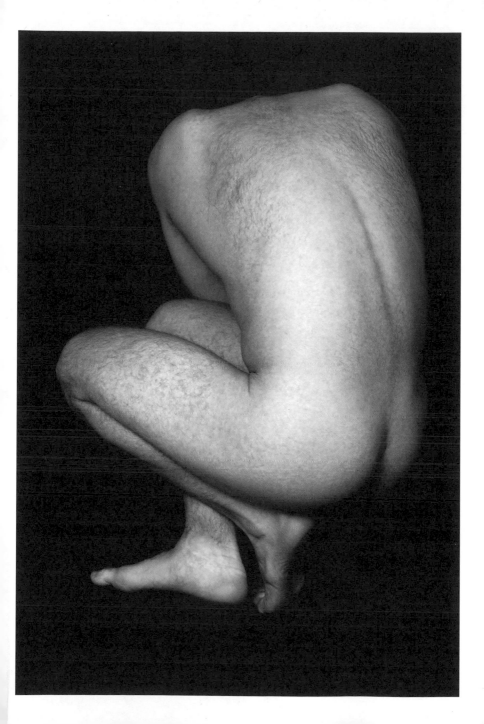

[T]he origin of art, basically, is . . . impulse to seduction . . .
all forms of art are a kind of excessive affection of the body . . .
the kind which is also generated in sexuality.
—Elizabeth Grosz

I. The Part About Wanting

start here. start with your hand touching the
page, the page caressing your hand, your fingers
moving over and against the words even as the
words move across your lips so that here, in the
beginning, an almost opening, an almost place
of sound, somehow, as if the page could be a
place of possibility. as if a book could manifest
want out of the darkest matter of the mind. and
so a body brought forward. a body brought into
being and pushed into purpose. an unmasked
story of eros, moving outward and forward, carnal
movement radiating out of the planed and paired
coordinates zero, comma, zero, a place of genesis
immanent in the framed space where the body begets
a narrative, each word, every sentence, all the pages
pressing all their insistent diction up into the fissures of
the mind's imagination until the psyche comes unbound
amid the pieces and fragments of some unnamed present
absence, rendering the reader and writer, sweetly undone

[to begin is to stop beginning]

wind through the grass. breeze in the face. sun descending and light receding. now a barely lit room, a window centered in the farthest wall. through it a panorama view of mountains and plateaus, ready points of departure somehow made available for excursions into the wild and unknown. here, stairs, stars, and passages open onto fields of strange potential, naked unnamed places where trailheads appear, hidden byways that descend and ascend over the veins of mapless swollen landscapes so that each receding path moves against distance, plotting a course using words typed into the surface image of the story's inside and its outside. and so the text begins again. it starts itself anew with an absent script of no-names, the dramatis personae of no one and *nadie* such that some dark assembly of figures begins to people the pages with both shadows and whispers. as such the givenness of the book's negative and partial space yields a structure wholly appropriate to the lexical ordering of the book's best imagined edifice, a jumble of words become a tangle of bodies. these touch and feel and hold each other tight. they grope and grasp in an intermittent outline of instances and happenings so that all associated fragments add up to become a tale of necessary yet impossible love. and so the revealed details of incidents and accidents taking place

in distant undisclosed locations where mouths and hands appear. where arms and legs appear. to fill and fit the space of want and need with the repeat motion of both heat and breath. as such a complex of words, a sequence of sentences, the rise and fall of stanzas and lines and paragraphs here arrayed to play hide and seek with the heart. they hide the heart in a box and push the blood deeper into a measured distance into darkness. and so now scenes fitted to words. and words fitted to ideas. and ideas fitted to form so that form becomes the frame around the self as it gropes toward unfound experience. here the set is as big or as small as you want or need it to be. a place of play and open possibility. a location in which bodies move forward and sideways, downwards and backwards, finding the curve of an arc in a sequential frame that bends upward and forward even as it falls to climb and bend again, such that, in this broken space of sound, in rooms of situated circumstance, new found feelings of grasping free abandon. as if want and need could gesture toward the direction of release in impermanence. and so now, by twist and turn, through bend and fold, the continual return to a room with a window centered in the farthest wall. here there is sufficient space to make things happen. as such today is a place made for the journey of appetite. a place of force and energy, of sound and imagery, a place where feelings and emotions vibrate into and out of the extended

limbs of the variable and multiplied self even as this variable self falls forward and outward into immanence. and so time and time and time. time as time. time as duration. time as instants or moments passing into fragments of experience captured in and through exponential geometric patterns of entanglement. here then an outline of two chairs placed adjacent and seen as if in profile. and now the sudden felt weight of some sort of energy stacked up between them, as if a certain sense of gravity, a shared and mutual force of becoming-in-attraction was growing denser now between them. here then the blurred image of two figures made to sit and face each other. these can only be, the reader in a mask and the writer rendered naked. and now the pure becoming of the world as word even as the writer enters the reader with the force of genesis and the reader comes to inhabit all the writer's assembled broken written passages. and though you cannot see it, you somehow feel it, the presence of a world taking form on the surface of the page as words testify and speak and pray, saying: *in the beginning was the body. and the body was made flesh. and the flesh was made word. and the flesh dwelt among the words in which the body was the narrative. the body made itself the narrative.*

[the book of malleable creation]

I

maybe she is lying down. maybe he is standing up. maybe she is lying down on top of him. maybe he is standing up inside of her. of course the world is gone. has disappeared. has slipped inside of sideways, where the heart flees, the world breaks, the day shivers, gain becoming loss amid instants of abandoned inhibition. and so now, the heat and the noise. the colors and the lights. these cling to these assembled bodies like static electricity, energy shedding form inside the dense air of passing minutes as desire spills loose to move of its own accord. and so evening is time, and time is motion, and motion is the time of these assembled bodies standing in for the presence of being, the being of bodies conjoined and made present in the temporal space of some forever-ever-never-now. it is in the manifold of this given situation, in the transitory and incomplete suchness of such broken passing instants that the self is multiplied. and the self is felt. and the self is held even as it shivers and breathes. now the self is embraced as a structured conjuncture brought together as fragmented pieces made present in communion with a partner. as such she shows him and tells him and teaches him: the locations of his forever-missing-puzzle-piece. and so he responds as she

responds as he responds, and they reveal to each other the softest places of some collective momentary displacement. in a sense they are teaching each other the bodily grammar of the present moment's physical syntax. a place to speak and pray and say, *somehow.* or *maybe.* or *please again, maybe.* in the open spaces of their often ever sometimes. because they're never where they are. we were never where we were.

2

I had my own private language. so did you. so did the others. the others had their own private language. the words, the sweating grammar, the silky phonemes pushed us all, first, into a corner, and then, second, into one another, so that over a series of moments we moved across the east and west of our bodies, where we were all, each and all of us, holding both a sign and a number. and we were all holding tall glasses of water. and the water glowed. and the glasses were lit up. they were shining mightily. for each and all of us. for everyone. or everything. in this time. in this place. in this given outer limit. where no one was named. and no one was seen. neither by us nor by the others. still the evidence accumulated. it was gathered in referenced testimony and minor testaments that gave our lives form, that fed us to motion so that each and every one of us began to live inside an afterlife of pleasure. an afterlife where desire flowed and desire fell and desire was measured against the curved surface of every passing moment, even as each moment or minute remained, still, somehow, measureless. as if the instances and happenings of collective physical enrapturement could only now be represented as complex addends or multiples being

multiplied to be slipped inside sentences and paragraphs devoid of any concrete referents. and still I see all the repeat imagery. the slow and heavy moments. the minutes and the instants. that never did occur. that never could occur, such that, in each imagined happening, no one ever saw anyone. they only saw themselves.

3

in assembling the picture, in arranging the setting, let me be more responsive, more provocative, concerning your needs. in serial poems and by means of twisting bent reiterated form, the reader and writer are moving into one another. they move from room to room, from one scene to another, and though the scenes have no discernible telos, there is a serial presentation of forms in which bodies join to form a narrative. in this context, in this setting, desire's multivalent forms become a source of motion, the origin and the locus for the book's hidden pleasured impetus. so think *now*. think *again*. think *maybe*. slowly place yourself inside all the latent sentiment. put your hands and fingers there and feel the liminal urge expressing itself through an assemblage of words soon become images. enactments of fabricated memory depicted as the play and sway of some visual melody repeated over and against the inner surface of your eyelids. here and now, you encounter a story of knowing but not knowing, a strange found feeling of having but not having. perhaps your lips could describe it. the way it feels. the way it tastes. the shape of the hunger that grows to encompass you. still it's hard to describe: the way that you're feeling, the pleasure

you're taking. or having. or giving. it feels both sudden and electric. as if purpose and reason were being now being made manifest as multiplicities in and through the present moments of the flesh, here, in being-time, where truth is a warm spoken immanence. it feels something like, never-before and. ever-never-after.

slow, dark and invisible, the reader removes her mask. she enters the page. she takes off her shoes. she removes her hat. she brings her body forward and sideways, easing and pulling herself up against the print and type of typeface. and she is the weight of the words she will now put inside of herself. and she is the weight of the words she will press to the folded space of her ever present *here* and *now*. this happens in a slow and drawn out sequence. it happens in undressed rooms of how-to. and now, the protagonist, the antagonist, the agony. where the windows are cracked. and the doors are open. and the curtains are drawn. between every floor and ceiling, there is a damp and heavy feeling, as if hunger, thirst, and appetite were merely instances of continual emergent motion now made present in sentences assembled to stand in for the presence of being. at times you are unsure what any of it means: the linguistic construction of fated incidents and accidents. the entropy of having and giving and taking and being taken in the unfolding bend and pull and thrust of incomplete and partial couplings experienced now in the scattered murmur of indecipherable excerpts of both speech and dialogue. between all the lines and phrases, a certain

sense of a grasping pulling feeling. need and desire lay hold of your hands. they pull and carry your fingers down, over, and across, the hungry surface of each waiting, unturned page.

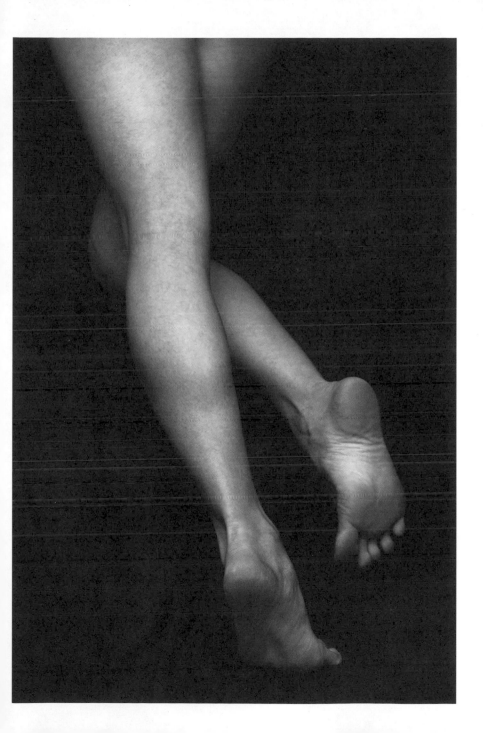

II. The Part About Having

[the book of liberty equations]

freedom is you taking
your body and walking into
the jealous eyes of god. into
the incomplete measure of
his incomprehensible hunger,
then freedom is you attaching
each and all your pieces to
all the gone places where
god would abandon us. to the
hunger of his hunger. to
the code inside our code.

I was over there. I went
beyond vision and reach
and I gave myself up. I gave
my body over to the chapped
lips of time, to the crossed-eyes
of time. these were seated in
a lap of legs. they were held
inside a folded field of arms
wearing a theory of theory and
anti-theory, a theory of no-theory
but rather the wages of theory
the mechanism.

your fingers
in my mouth.
your mouth
propped up against
the landscape and the
landscape thrown into
motion. this is how I
picture it when I
picture it, when I see the
scene inside the scene I put
inside your head. your mind
is naked caprice. it is variable
movement played out against
the wettest surfaces of
our mutual untracked
happenings.

we have rolled into
a ball. we have become
a small white pill in the
silver of our linings. we
seem to want to. we seem
to need to. to need to want to.
to want to need to. to want to
find our way forward.
into this sequence.

the present is
right here. it
waits inside the
want of you. it
drips inside the
shape of you, an
appendage to
disquiet.

you are free. you run
your hands through your
freedom and you are
always and invariably
more and more free. it
feels like something you can
feel but don't see. it feels like
the side of your head
floating beyond.

[the body: a poem of entanglement]

and now the body
the body oft alluded to
this body which is the book
this book which is the manifestation
of desire loss and regret
it is distance in time
it is the white silence of the page
this body with a wet lover's mouth
this body of misdirected meaning
it is recurrent in memory
it is breathless in blindfolds
this body of new hope
this body typed against borders and
pushed across boundaries
it is the raw sugar of entanglement
it is the burnt sugar of determined incompletion
this body of an absent *nameless wildness*
this body of occupied space in some other country
it is a field of thought and deed
it is the wrecked beauty of day written against
the misplaced pieces of
an unreachable map

and now the curve of a hip
the nape of the neck
the small of the back
a body of diffuse disequilibria and open instability
arms and legs and fingers and mouths
pushing and pulling and sliding and entering
unseen form in the shapeless gravity of want
and so the bent elbow
the cocked eyebrow, the painted fingernails of
a body on top and a body on bottom
giving and receiving constant encouragement to
a body finding form in disassembled narrative
a body of motion pushed inside the stillness
it is the density of lack
it drips with the idea of intersection in void
this body that is taken and given and given yet again
to hum at some vanishing point
to purr like the alphabet
this body marked and covered with the black filigree of
typeset
this body of painted red arrows descending into everything
it lays in wait for you
it calls and points to you with
undressed sound and naked imagery

and so now an exhibition of frames
a sequence of scenes
some quiet disorder of lines
arranging and exposing the subject imaginary to
this body of burning paper cities
this body of a blonde moth in winter
it follows you and you follow it
this body that is momentarily full yet continually unfinished
this body of experimental beauty receding against distance
it is a habit you inhabit like a habit
this body of new subject positions
this body receiving light in space
it is ineffable, ephemeral, impermissible
this body that is both archive and catalog
this body that persuades and abandons you
that both absolves and forgets you
this body that withdraws from you, that escapes in you
it is the milk and silk of wet cotton and hard darkened corduroy
this body of brushed leather
this body of torn denim
all its routine propositions
its episodic overtures
bending and twisting and pulling and tugging at
the search for self in the shape of the other

[the book of lust]

: | :

inevitable and never.
you should be the
alphabet in my mouth.
you should be the
wide ruin of my eyes.
you should be me
pretending to be you
pretending to be me on the
skin of the present with
a hundred different hands.

: 2 :

journey to thirst. for thirst. across
distance.
journey into and over the surface of
the other.
into seasons of the second person
singular.
beyond beneath, before, below, because.
because someone said yes. said
yes and maybe and sometimes.
to the now open mouth of the world. to
the loose hands that carry the wet mouth of
the world. into this sequence. into the
fragrance. at the end of each sentence.

: 3 :

my hands bear witness to
your mouth. your mouth
bares witness to my hands
there is text between us.
there is an image of water.
blinking and shimmering
between us. it creates iterated
motion. creates thought and
sensation. in the spaces of
the flesh. in the boundaries of
time. here and here and here.
in each place you place your fingers.
in the spaces you mark my margins.
with symbols of the unseen.
with texts of the unknown.
for something nothing *nada*.
for the printed type of *nada*.
forever and never. amen.

: 4 :

except as otherwise provided
your legs wrapped around
the landscape. sometimes your
fingers in evermore. anyways
anyhow imagine the shape of a
horse on a coordinate plane.
imagine it running into and over some
story out of time. the horse gallops
in and through its narrative. it
moves with and without purpose.
like nothing and nothing and nothing or
something you wish you had a photo of.
you wish you had a photo of: the horizon
erased. the horizon replaced with
all of your lovers, divided by one.

: 5 :

five o'clock is too early
for your sticky and edited mouth.
you put your hands on the inside
and your mouth on the
outside. you put your
hands on the inside and
your mouth on the outside so that
you can be the sense of things
color tones stitched into
an abstract sky.

: 6 :

or your legs in
the fish aquarium of the
imagination. or your
arms caught up with the
syntax of my body. being
neither true nor not true
it's not a sin to love you.
not a sin to show you
the kingdom of the instant
the moment of the flesh.

: 7 :

complicit veins
complicit ears of
eyes of hands
you fit
my zero point zero.
you fit my
one
point one with your
two point two your
three point three and
the sky is laid out.
like a silk sheet.

: 8 :

vast planes of distance.
of automated silence. and the

rules are we make up the
rules as we go. the rules are

we make up the rules when
we come. either or. either

my mouth or your hand.
either my hand or your mouth.

whenever we cannot can.
wherever we will not won't.

: 9 :

bewildered pursuit
of the
fig.
of the tooth of the
hands or the eye
of the wish.

you have my mouth
you have my hands
you have my eyes.

my hidden quantity
my static number.

the better to eat you
with.
the better to lick you
with.

: 10 :

just put me in your mouth
where the letters and numbers
are made. please put me in
your hands where the words
are divided and the numbers
sort themselves out. the thought
that waits inside of you waits inside
of me for stairs beneath the day and
a ladder through the night so that what
cannot can. what will not won't.

: II :

hunger was sovereign.
desire was sovereign.
it twisted into the shape
of you. it grew inside
the shape of me. here
and here and here. in the
place you place your
fingers. in the space you
mark my margins. with
shapes of the unseen. with
the text of the unsaid.

: 12 :

am I inside you?
are you inside me?
is my dream inside
your face? is your face
inside my dream?

we go forward into
the matter so that we
might matter. we go
further and farther

into the matter so that we can
move our bodies closer to the
heartbeat of the matter and
our legs go down. into the

ground. into the
soil of our wanting.
and our needing.

: 13 :

you have my eyes

you have my ears
you have my mouth

my hidden quantity
my static number, the

better to touch you with.
the better to steal you

with.

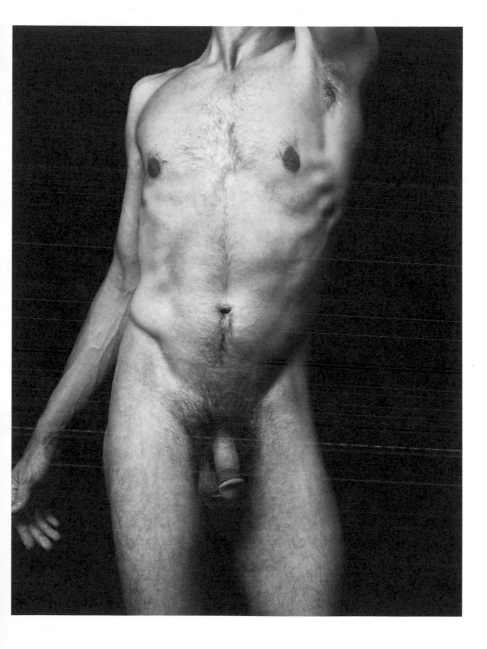

III. The Part About Needing

[a book of weighty repose]

cessation of movement. full circle in a sense. and now a temporary completion of space, a closure of distance, the filling in of absence with silence and volume and matter. open day waits, piled up, as if the temporary nature of things could be represented as simple objects situated in space. as such a heap of clothes, a sack of thought, every article of anything, resting in its given place, here and there, where disheveled minds disassemble thought and pull themselves into waiting different meanings. so now a T-shirt pulled over the limbs and onto a torso. and now a body reordered and fit for completion. everything here, moves slow and slower, slow movement becoming, itself, somehow, beautiful, frame upon frame, the full slow motion of breath rising to take up space in some far expanse of blue, a wide open emptiness that holds and protects you. that keeps you at rest in a glade of widening, darkening, form. as such, a lamp going out in a distant clearing in the woods, the imagery guarding and completing you. fixing you in a sequence of shadow, light and emptiness, the various fragments forming a sort of dozing sleep wherein all the pigments are lush. and the flesh is cool. and clean. the flesh is wet. as wet as the water you have taken. the water you drank there.

now a point of long pause, a place of weighty repose, and the habitation of self as a room wherein you are supine in thought. or you are prone, or you are seated, or you stand, or you are bent and folded, where you rest, your feelings and thoughts stretched out, variously, to fill each and all the angles rising slowly off the tracked surface of the trace you set against the present. and so a place where the page gives way to some second space of self. in this sense, heated suggestion giving way to a sense of the possible. even now amid the unseen form of the matter, the broken and incomplete partial narrative. that waits for you to finish it. to complete the story never out of reach. as such, a large room with glass walls. an image of an auditorium or cathedral. a large and open building in a field of unknown reasons. it stands there, in a picturesque field of green and gold and blue, a hollow in the distance where I am reaching out through space in every direction, to build for you an invitation to return again to sleep. in this place where the body can whistle and hum even as the mind smiles. and vibrates, shivering, its presence of being so alive and splayed-out, and bent, and waiting, in repose, in this exposed symposium of glass and light and words, all the words moving through the tension of sound that now frames the broken space collected to be torn. beneath the circle of the sun. the sun that shines down on every page.

I could be divided.
I could be added and
subtracted and divided.
it might feel like a hundred doors being opened.
it might feel like all the blood that makes us
matter, that takes the pieces of
this matter, and bends them
into form.

[a book of ellipses]

[a]

this. some. this.
shall. it shall make
for whomsoever the
want of limbs inside
a landscape. here a
doorway opens only
to close. to shut a
space inside itself.

[b]

I wanted to be water in a
puddle. then I wanted you
to show me how weight
could gather in my body.
we eat at the table and not
under the table. we eat the
bread and fruit of our table at
the table and not under the table
where our legs go down, into
the ground, into the soil of
our wanting. and needing.

[c]

I hide you inside me
like a number. I feel
the warm pull of you
inside me like this number.
this number without
size or shape or color. it
feels like something you can
feel but don't see. it feels like
the side of your head
floating beyond.

[d]

this no.
this not.
this nowhere.
this nothing.
this *non.*
this *nicht.*
this never.
this no one.
this nobody.
this *nadie.*
this *nao* of the ever-always never-present.
is it absent yet possible? this feeling of
void or absence or emptiness.
it writhes in open space. it rubs and presses
its face over, up, and into
all the things we could
do and be here.

[e]

the red arrows you
paint on your breasts and
the white letters you trace
on god's lips suggest
some other kind of motion
a different way to travel.
here my magic arrow is
upside down inside you.
here some hidden stripe lays
inside out beneath me. beneath
this quantity of hands you've
attached to, my reason to be.

[f]

the red smear of everything
dripping down the front of you.
dripping down each and every
side of you. wanting a taste.
wanting to touch, the open mouth
of god. to sleep inside his error.

[g]

some machine clicks
and ticks and licks the
smoke of your soul. it
sweats inside the shape
of you. it waits inside the
want of you holding empty
hoped-for openings.

[h]

the face game.
the mouth game.
the body game in which
love is made or
unmade atop or against
the blurred angles of the
incomplete other, some
once or future
imaginary lover.

[i]

it was a long time ago.

I cut a hole in the center
of god and I
walked through. I climbed

inside his distance with the
whys and wherefores of
my body.

with all that it wanted.
with all that it needed.

[the world is worth it]

mere moments in the sweep of time.
some place inside a day inside a minute.
a place where you were close in and
against distance, an unknown form, an
an unbound shape while all around the
shape of the landscape was ice cream
and roses. I placed my lips inside your
face and kissed your body backwards.
all the while you kept the camera running.
you kept the car running and the windows
down as you went down and pulled my body
forward into a space between parentheses.
in the next scene you pulled off my shirt and you
plagiarized me. you did it with the letters of
the words you hid inside each alibi. and still
your mouth was not a path into truth or
self-redemption. your mouth was simply
your mouth. it was the jagged space of
sound you slipped inside me sideways.
like some other person, place, or thing.

time moved. time walked. time limped around
town turning loose pages that often were returned to.
the sky was falling down and the earth was growing up
into it and there were trees and leaves and dreams of
sleep beneath a field of stones. and you were an empty
suitcase. you were a carburetor or revolver or you
were a stone's throw away or you were a coyote
and I was another set of wings, aircraft, bird or angel-
moth wings. or I was, alternatively, an acorn or oak leaf
or tattoos and stag antlers. or I was some wounded hare
floating above the script where you were many and you
were one, even as you were composed of musical notes
made manifest as countless fish composed of tiny different
colors. and so you called to me. you called and spoke of
hope or fate in episodes and memories in which you
said I was incorrigible, but I was not incorrigible, even
as I was, right then and there, the moon and you were
the sun riding an escalator with my headphones on, my
playlist going. and we were still there. and we were still
going and going and somehow sort of gone. maybe then
you carried dominoes or dice or very small thimbles of
whiskey. maybe you held a deck of cards inside your
hands or purse, even as you were, even then, cut-up

paper roses blooming from the pages, your heart beating red as it continued on, your arms and legs akimbo in locations and times and places that were and were not good enough. it was never even good enough. the dream was always better.

a page in time. some torn page of whatever.
it's complicated and problematic and tactical
because the story is or is not finished. still
the book contains no photographs. it's not
a sculpture or a painting. it's not Solomon or
the Song of Solomon. still with words I have
made of it some other Song of Solomon. and still
it does not contain you. this book will never not
contain you. it will not contain your full narcotic lips.
it will not contain your contraband eyes. it will not
contain the ways you play with motion as you teach
yourself to trespass. in the misprint of these pages in
verses made for breathing, all these words will fail you
even as each and all these lines add up to become the
many-sided void of you stamped against each page.
because the flesh is willing but the spirit is weak.
the flesh is willing but the spirit is weak. like a hunger
in my hunger. like some code inside my code.

blindfolded, trouble will or will not
find me. and then, and then, *nevermind.*
and then, *oh, oh, nevermind,* she said.
and she opened the book and she entered
the pages saying, *oh, oh, nevermind.* or
some days are harder than others. and
some days are an open door but other days
are not, are not an open door. and so she
readied herself. she prepared the many million
even billions of cells that composed her with
words and sentences, with letters or phrases
that would now appear to her in all the places
she brought herself even as she readied herself
to come among the syllables, the songs and
halftones, the vowels and consonants she held
inside the outstretched fingers she used to push
and pull and bring herself there, sliding her arms
and hands and legs up against the surface of the day
while she moved herself forward and backward toward
some unknown yet invoked end, a place of completed
incompletion, a location at the edge of silence or absence in
this world of hard ripe fruit and too little or too much time to
spell it all out, the meaning of the words she would carry in
her sideways, even as, she returned and brought herself there.

in a forest of blur I saw you
projected like a shadow against the
far reaches of the wall. you were *contra*
la pared and you were all around me
even though your face and hands were
missing, were lost and missing from my
ever present sequence. and while I sat there
I imagined you put together with sound.
I thought of you stitched together with some
recombinant melody of splintered verse, the
serial repetition of you an eventful fractured chorus
I would fasten to our assembled mutual made-up
history. and so I imagined each or both of us with
our limbs extended, our lives unfolding, our
lives pulling themselves open as if we were
two windows facing one another, the two of us
offering each and both of us a way back in.
and as I entered myself through you and you
entered me inside of you, you told me you would
teach me a new testament of breath. you said you
would feed me all the red and yellow pears
of my life.

before truth, there was a wound.
and it was typed into being.

there was a hole filled with print and
it expanded in

contraction and it, it sang itself.
it sang out loud. in long tones. in
abbreviated or severed
tones . . .

and then, and then, never mind.
and then
the subject said, see, I closed

the windows, see, I closed the
curtains (or)
see, I left the door ajar. so *gaze*

at me and then gaze at these
words. picture the pieces, the
fragments, composed in and with

novel forms of artifice. picture a
blurred
figure, a sore body clinging to the surface

of desire with said fragments
as/while/when you incomplete me
in space. right here
in this poem, (right here) with your

wristwatch, you incomplete me in
time. and the gap you've created is a
special kind of animated absence. within it

I live and breathe and have my being so that
I am "becoming" like a perfect word
conjured to sit inside this silence.

and now I'm coming to you in super
slow motion.
and now you're coming for me
in super slow
motion. and we're (right here). we're

playing with the machines of our
bodies. we play hide and seek with the

machines of our bodies so that

the billowing loose sleeves of ourselves join
to flap loose (like a flag) over a
cut-open landscape, the paper, the

gridlines mapping out all the black
and grey emptiness, the eternal blue
distance stacked up

between us. each centimeter, each
measured-out inch being the total blown-up
backdrop painting apportioned

expanses and inhabiting the failed cinema of
our minds now given over to words.
and still you're coming for me in

super slow motion. and yet I'm coming to you
in super slow motion. as such
I'm here with a compass in my pocket.

I'm here with my band aid heart and
you're over there, seated at a table, your
wrinkles, your eyelashes, each of your

paragraphs, waiting to interrogate me
waiting to show me but not tell me how I can be
purposeless but still intelligible. it's

uncommon sense. my hat and shoes and
belt are uncommon sense. the kind of
uncommon sense that appears even as it

recedes in continual deepening retreat so that
words are organized to function like a vision
of some disappearing person. I am speaking here

of certain measureless quantities of loss.
(or) I am speaking of certain kinds of sums that
never really capture (or) absorb you. still the

event of our mutual gravity keeps feeding
the distance an accelerated closure, a certain
kind of tightening in which the lines we've drawn

around ourselves keep narrowing, keep
folding us into one another,
collapsing space where we embrace this our

separate but proximate positioning. and so

(and such) (and then) there is a different sort of
silence that follows you when you move

yourself over into me. into the lines inside my
poems. I cannot explain it but each encounter
starves truth with blind prejudice such that

with blind prejudice I could eat each day for
miles. for mile after mile (or) mile upon mile
the miles subtract the miles. the days subtract

the days even as I stitch empty words into the
surface of each and every page thinking all about
the page as if the page were nothing more than

a bound folio of words collecting all the
unnamed moments I would spread against
the paper surface of your skin.

dear reader, beloved, my present absent lover,
have you figured it out? have you found the hidden
plot? have you unmasked the unknown answer?
can you undress love's *obscure object of desire?* the
book ends the way love ends, incomplete and fragmentary.
so substitute me for you and you for me. substitute I, *myself,*
and *my,* for *you* and *yours, yourself.* then sort it out.
puzzle it through. the room of the you-me, this-us,
contains a shadow script, a narrative making love to
the companionship of words. dear lover, my reader
beloved that will or will not be, I have changed the
meaning of all that happens here, in this very space where
we push and pull against the weight of each other with the
weight of these words. we are reaching for something we
can't even name. without knowing it we are moved toward
unseen ends. we are pulled toward heretofore unrecognized
objectives waiting beyond the borders and boundaries of
the hoped and wished-for, some fate living beyond all
preconceived ideas about means and ends and purpose.
so go ahead and strip it down. strip down the words and lay
the body bare. the narrative is merely fetish, some factotum of
desire and resistance, a location in which we engage each
other in serial repeat transference. dear reader, do you see

what I'm saying? do you feel what I'm knowing? it's the distant self inside the all-too familiar self we seek when we move our limbs over and into all the lines we use to meet inside the lines inside these poems. you've been looking for you. I've been looking for me. we've been looking for the lost selves we hide inside ourselves and all the words that pass between us.

in a field of loss or
completion or serial

incompletion I wrote a
song called *the best
parts.* I rode a horse
named
the best parts. I said

*whatsoever the hand
whatsoever. whatsoever
the mouth
whatsoever.* here inside

the space and shape of
here. a place my body

lays down, a place each
moment becomes

the dripping weight
of day.

invisible alphabet

alphabet that bleeds, the

alphabet of your body and

all that it spells: my

mouth against yours.

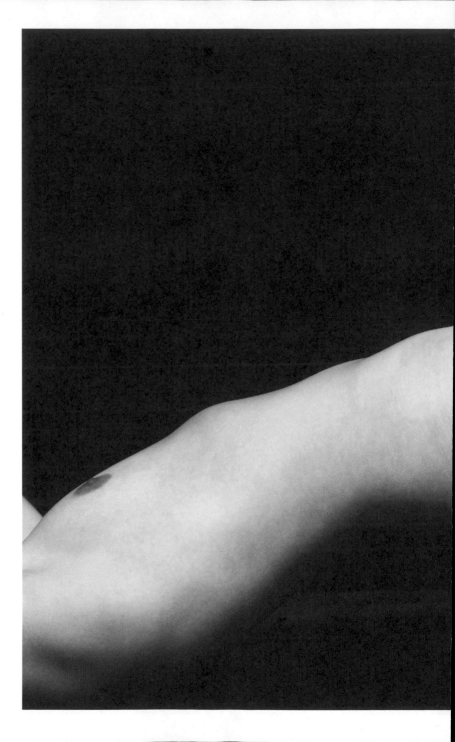

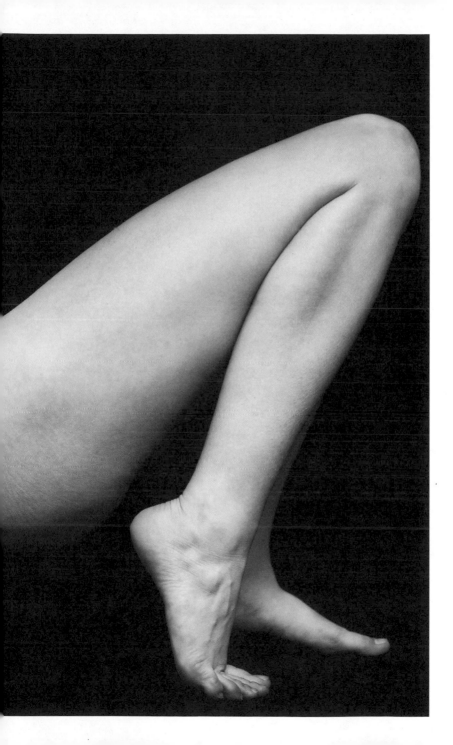

ACKNOWLEDGEMENTS

Thank you to Michael, Christian, Bethanie, Moira, Tim, Richard, and Brad. Your contributions to this book were invaluable. Thanks especially to Jacob, Samuel, and Finnegan, my three boys, who make me smile, even when I'm down. Stevie, thanks for being exactly what I needed, a friend and honest interlocutor. Amy Wilson you were a bright light in dark times. Ned, thank you for helping me find my Zafu.

And thanks Don for making my book look like a real book.

Daniel Rounds's poetry has been featured in *Aufgabe*, *3rd Bed*, *Goodfoot*, *XConnect*, *Fish Drum Magazine*, and *American River Review*. His first book of poetry, *some distant lateral present*, was released by Ad Lumen Press in 2014. He lives and works in Sacramento.

Jesse Vasquez is a photographer, artist, and curator from Sacramento. His work is largely focused on the phenomenon of having a human body and its connection to human consciousness.